PAINT!

BY
JOHN FITZMAURICE MILLS

D0995997

BRITISH BROADCASTING CORPORATION

John FitzMaurice Mills

John FitzMaurice Mills, FIIC, FSA, FRSAI, FRSA, is a dis-
tinguished teacher of both painting and the history of art
who has been involved in television programmes on the
arts for more than twenty years. He has lectured for
Oxford, Exeter and Dublin Universities, as well as in
Europe and America, and is the author of over forty books
and an audio-visual History of European Art. He is cur-
rently President of the Royal Drawing Society and a Chief
Examiner in the History of Art for the University of
London. His own paintings have been shown in major
exhibitions here, in America and at the Paris Salon.

This book accompanies the BBC Television series *Paint!*
first broadcast on BBC2 in Autumn 1981.

Series presented by John FitzMaurice Mills
and produced by Dick Foster

Published to accompany a series of programmes
prepared in consultation with the
BBC Continuing Education Advisory Council

This book is set in 10 on 11½ point Bembo, Linotype VIP
Printed in England by Belmont Press, Northampton, England

© John FitzMaurice Mills, 1981
First Published 1981. Reprinted 1981
Published by the British Broadcasting Corporation
35 Marylebone High Street, London W1M 4AA
ISBN 0 563 16458 1

Contents

Foreword

Picking up colour with a brush or knife and placing it on canvas or paper can be an exciting and liberating sensation. Can we all paint? There is only one way to find out, and that is to have a go. We do not know what the stumbling ways of some of the great masters were. But it is on record that a fair number of them, in the past and today, have suffered from the numbing moment of doubt when confronted with a blank sheet of paper or a pristine, empty canvas. For many would-be painters the great obstacle is, quite simply, fear.

But just what is this fear? It is not really physical, because the worst that can happen is that you end up with just a mess of paint. It is really something much more subtle – a silly nagging whisper in the mind that keeps up a chorus of 'you can't, you can't, you can't!'

The brushes are made by craftsmen. The colours set out on the palette are the finest that the manufacturer can produce. The paper and canvas are of good quality. But they are all mute, still, waiting to be brought alive by the individual and imaginative style that is the painter's. Find that initial moment of courage and you can be away into the land of expression that has been found by so many. From the first strokes, which may seem weak and aimless, an excitement can develop as colours and forms start to grow in your mind, fed by visual titillation and translated into being by the hand and the brush. Painting can be an adventure towards an infinite horizon that is there to be found by anyone; the process can be a therapy in itself.

The vital point is to retain that unique thing that is you. Following easy guide-lines that have been laid down by someone else, filling in indicated areas for colour, leaning too much on slavish copying, being content with attempt-

ing little – these can all obstruct that current of inspiration and enjoyment which is there.

By all means draw from the achievements of the masters of yesterday and today some part of the creative power which they found. Go round a gallery or study a well-illustrated history of painting. There are few places where greater diversity can be found than in the works of artists – Mantegna, Dürer, Rubens, El Greco, Hobbema, Rembrandt, Gainsborough, Turner, Holman Hunt, Monet, Douanier Rousseau, Picasso, John: the list can go on and on. Just one small fragment of their power can be a leaven to transform painting for you from something that appears to be a locked door into a truly enjoyable experience.

The American Robert Henri, active as a painter and teacher at the turn of the century, wrote: 'Don't worry about rejections. Everybody that's good has gone through it. Don't let it matter if your works are not accepted at once. The better or more personal you are the less likely they are of acceptance.' So, if you really want to find the most in your painting, do it your way.

1 Methods, equipment, materials

Since the very first painters created their vigorous pictures of animals, in places like the Lascaux caves in France, and Altamira in Spain, using little more than natural clays and burnt sticks, artists have often experimented with strange materials. The dry pigments have been mixed with fig milk, juices from various berries, animal blood, random oils and gums; men were seeking to find substances that would mix with the colours and bind them to give a suitable working consistency. From all this emerged the main media with which the painter works today.

Whatever medium is chosen, the pigments are the same; it is the vehicle, the substance that is mixed or ground with them, that gives the different characteristics of the various methods. The colours available have increased not only in number but also, in many cases, in quality. Some, like the natural earths, umbers and ochres, have been used almost since the start. In the last two hundred years chemists have produced rich, strong pigments which have replaced earlier fugitive, that is, unstable, and often highly poisonous colours, and also new tints that make the painter's task much simpler. Today you do not have to spend long, tedious hours with a stone muller and slab grinding down the pigments until the particles are fine enough to use. This is all done for you and tidily packaged in collapsible tubes, not messy bladders or easily breakable glass phials. Visit your local art shop and the main difficulty can well be deciding what you need – some makers list more than a hundred colours. In chapter three advice will be given on a possible selection of colours with which to start.

Painting should be enjoyable; maybe there will be moments of anguish, but overall it can be exciting and

entrancing. To help this process the simpler the array of materials can be kept the better, so that the main creative action will not be hindered by fumbling through a clutter of things.

The five main methods

Oils

The exact date when this most popular medium was discovered cannot be fixed. It is likely that it was a gradual process, which started in the fourteenth century, possibly in Italy, and was certainly developed at the beginning of the fifteenth century by the Flemish painters Hubert and Jan van Eyck. The pigments are ground into an oil, and this gives them a richness and translucence not found with other media. The most popular oil is linseed, although colour makers and artists have used a wide range of oils, including clove, hempseed, pine, rosemary, safflower, spike, sunflower, tung and walnut. Poppy may be used where it is desired to slow down the speed of drying. When painting, the colours may be diluted with more linseed, turpentine, turpentine substitute or various proprietary painting mediums. Thus the colours may be brushed out quite thinly. If they are transparent they may be applied in this manner, as a 'glaze', over previously applied colours that have dried out, in order to give subtle changes in tone and tint.

There is one basic, important rule for lasting permanence with oils, and this is, do as the house-painter does: 'start lean and finish fat'. In other words, do not lay thick, rich coats one on top of another. Thick textural effects can of course be worked up with brush or knife, but it is best that they should be put directly on to the primed support and not where there is previous work. An oil painting may take up to seven days or longer to become skin-dry; all colours do not dry at the same speed. Where there is really thick paint, a complete dry-through may take up to a year or even longer.

Supports for oil painting can include stout papers, cards, cardboards, hardboard or wooden panels and canvas. The latter should either be stuck down firmly on to hardboard or cardboard, or stretched over a wooden frame which has special, mitred corners into which small wedges can be driven to tighten the canvas. Whatever material is selected as a support, it is essential that it is prepared correctly. Papers and cards should, at the least, be given a coat of size

to reduce the absorption of the oil. Canvas needs first to be sized and then given a coat of primer, and the same treatment should be carried out on hardboard and wooden panels. If you plan to work on an extra-smooth surface, a gesso ground can be laid on hardboard or wood. This does involve quite a bit of time. Gesso is basically a mixture of a plaster and a glue. Whiting will serve well enough. The first mixture should be prepared with hoof or rabbit-skin glue so that the consistency resembles heavy cream, and then brushed over the panel. Leave for about forty-eight hours and then make up a second concoction with more liquid glue to a thin cream. Brush this over the earlier layer and, when it is hard, after several days, bring up the surface by gentle abrasion with the finest sandpaper. The finish should have the feel of polished ivory and provides a remarkable surface for working on with fine detail.

The most popular brushes are those made from quality white hog bristle, but, again depending on personal style, brushes made of hair can be used. The synthetic bristle and synthetic hair that are making their appearance are also well worth trying, and they can be quite a bit cheaper than the others. After a painting session all brushes should be well rinsed out in turpentine substitute, and if some colour remains they may be given a washing in cool water with a little pure soap.

The choice of palette will depend on methods of working. For outside, a mahogany palette may be the best or one of the disposable paper variety. For inside, some still

A selection of palettes. Shape is a matter of personal preference, but the material must suit the type of paint in use.

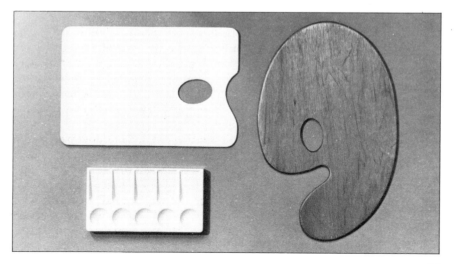

11

prefer a wooden palette; alternatively, a sheet of plate glass on a table can be excellent as it provides plenty of room for mixing, and a sheet of white paper can be placed under the glass to help judge the colours. Hardened colours can be removed from a glass palette with a proprietary paint remover, but it should only be used on a wooden one with care. Resist the temptation of cleansing caked brushes with such liquids, for they will almost certainly damage the setting and possibly the bristles or hairs.

Beware of mixing odd materials such as waxes, strange oils or varnish recipes in with the colours, for many of these can lead to cracking and other unpleasant effects as they dry out. Never be in too great a hurry to varnish an oil. If it has been painted around three weeks it should be skin-dry all over, although it is wise to test areas carefully where crimson and perhaps cadmium yellow and cadmium red have been used as, under some conditions, they can take longer to dry. Then, if the picture is intended for an early exhibition, it may safely be given a thin coat of 'retouching varnish', which will bring up much of the rich look that was there just after painting was finished. But never apply the final picture varnish for at least a year.

Water colour Under this heading, in the broadest sense, come all the media that are water-based, such as poster colour, showcard colour, distempers, powder colour and gouache. But in the purest sense, true water colour is a transparent medium, relying to a degree on the kick-back of light from the white paper through the colours. For the finest effects, opaque colours should be banned from the palette. The method opens up experimentation with the overlaying of one or more colours on top of others, thus creating tints that are formed by transmitted light rather than stroked together on a palette or in a bowl. Papers, cards and what are called 'pasteless boards' are the most suitable supports for water colour. Where possible, use the best quality paper you can afford. It needs to be heavy and thick, and can be purchased with a smooth 'hot pressed' surface, medium rough known as 'not', or 'rough', the last with some of the heavier papers being truly rugged and allowing for some unusual and bold textural effects. Green's pasteless boards, Bristol and fashion boards will all serve well. The thinner and lighter rag papers, as well as cartridge, will need to be stretched on a board. This is fairly simple, and is carried out by trimming the paper to

within about 5 cm (2 in.) of the edges of the board. After this, place the paper face down and thoroughly wet with a sponge or piece of cotton wool dipped in water; turn over and wet the face side. Leave for a few minutes and then pick up one end and smooth down the wrinkles with the sponge or cotton wool. When it is entirely flat, stick down the four edges to the board with a brown sticky tape and leave to dry.

When choosing brushes, be particular, for quality is what is needed. Seek a brush that will hold plenty of colour without dropping it, and one which will retain its shape. Some makes are starched into shape to protect them, but this can also hide inferior setting and rogue hairs. It can be a good plan to ask if you may have a little water just to get the feel of the brush.

Water colours are supplied in various forms. In paint boxes they may be in tablets, metal pans, small porcelain pans, tubes or sticks. In the last form they are generally to be found in architects' or draughtsmen's offices, and they are used by rubbing down with a little water in a shallow saucer or palette. On the market, there is a large array of porcelain, enamelled metal and plastic palettes from which to choose.

Gouache

This is the name for opaque water-colour painting. It can include a wide number of techniques, from quite thin applications to effects similar to oil painting in which the brush strokes are left showing as intended textural marks. It is best to carry out gouache work on reasonably stout papers or cards. Those that are tinted can offer the chance of achieving some unusual and interesting effects. Textiles are not suitable supports, as any undue movement can cause the paint to crack and even flake off.

Brushes may be either bristle or hair, depending on the style of working or the effect you want to achieve. Washing out afterwards should not present any difficulty; water and perhaps a little soap should clear them even if there are residues of hardened paint. Palettes can be old saucers, plates or plastic wells.

It was painters like Girtin in the eighteenth century who first started to exploit the possibilities of gouache. It was found that the glue-bound, thick, opaque colours could be used with something like the vigorous brushwork of the oil painter, and striking and unusual effects could be created. When dry, these paints have an attractive chalky

13

look. Some painters have experimented by waxing or varnishing the dried paintings; these treatments can bring up a greater richness in the colours. However, it is wise to experiment on a piece of scrap card before doing this, as the wax or varnish can darken and alter the appearance of some tints, notably blues and the earth browns.

Tempera

This was the principal painting medium, apart from fresco, available to the early Italian Renaissance artists. The date of its first development cannot be pinpointed, although the Greeks are believed to have used a somewhat similar medium. True tempera is prepared by mixing the pigments with pure egg yolk and perhaps a little preservative such as thymol or formaldehyde. Extracting the egg yolk involves a sleight of hand. First crack the egg and then pour the white and yolk into one hand and roll around with the fingers slightly splayed until the white has poured away. Then very carefully pick up the yolk sac between the forefinger and thumb of the other hand, suspend it over a saucer and stab the bottom of the sac to allow the yolk to run out.

Egg tempera has an attractive matt surface with a slight, subtle sheen. It may be applied to papers, cards and cardboards and on these will dry at about the same speed as water colour or gouache. It may also be used on hardboard and wooden panels which have been grounded with gesso as mentioned earlier under oils. This method is the traditional way, and some of the early painters laid gold leaf on the panels which was often stamped with patterned dies. Once mixed, the paints should be diluted with water; never add spirits, oils or varnishes, as these will alter the finished paint film and very likely could make for impermanence. The medium is best applied with quality brushes of hair rather than bristle, and these should be well washed as with those for gouache.

The dried film of true egg tempera is extraordinarily resistant to the atmosphere and effects of heat and cold; cracking of the paint is almost unheard of. Once the colours have dried out thoroughly they become non-absorbent to water and even mild solvents.

One of the uses for egg tempera in the past was as an underpainting for oils. It is well suited for this purpose, as the dried tempera film has little in common with the oil, and once the underpainting has hardened, a thick-textured oil can be painted over with little danger of cracking. Egg

tempera, as with acrylics, can be well diluted with water and thus simulate water-colour effects, or with transparent colours can be used for glazing.

When the tempera painting is finished it can be left as it is, polished, waxed or varnished. If left alone it is best to place the picture behind glass. Polishing should be carried out with a silk cloth or high-quality cotton wool, and the result will be an increasing of the sheen and a slight enrichment of the colours. Waxing or varnishing should be delayed for several months after completing the work. It should also be noted that both these methods can change the tone depths of a number of colours, so experiment on a piece of rough paper.

Acrylics

This is the most recently developed medium. In the 1920s an American firm, Rohm and Haas, produced a number of synthetic resins which in the pre-war years were used to manufacture such things as knobs for furniture, heels for women's shoes, car tail-lights and some industrial paints. The last showed considerable strength and permanence. Those white and yellow lines on roads, for instance, are basically acrylic-bound. However, it was not until the late 1950s that manufacturers of artists' materials thought about using these synthetic resins as binders for high-quality pigments suitable for the artist. Since then their use has proliferated, and acrylic paints have been marketed under numerous names.

Although water-colour effects, gouache treatments and oil textures can be achieved with acrylics, it is best to think of them as a new medium and one that should be treated as such. The colours, bound as they are with synthetic resin which is the basis for many modern glues, have a strong adhesive power that increases with age and at the same time retains a degree of plasticity. Thus they can be applied safely to a much wider variety of supports than any other medium. They will take equally well on papers, cards, cardboards, canvas, canvas board, hessian, sailcloth (and other similar textiles), hardboard, chipboard, wooden panels, glass, metal plates, ceramic plaques, slate, stone and plaster. Canvas supports, wooden and hardboard panels, cardboards, cards and papers need not necessarily be primed or sized first, although it may be an advantage from an aesthetic point of view to brush on a preliminary coat of acrylic primer. Glass and metal sheets should first be de-greased with a piece of cotton wool

dipped in a little methylated spirits. If painting a mural on a plaster wall, one or two coats of acrylic medium mixed with equal parts of water will help considerably to consolidate the surface.

Acrylic paints should never be mixed with those of other media, such as oils, tempera, water colour or gouache; there is nothing to be gained, and doing so could upset the balance of their own structure. Neither should they be mixed with turpentine, turpentine substitute, oils or waxes. If the colours do need dilution, acrylic painting medium can be bought in varying consistencies, ranging from stiff pastes to liquids. The paints may also be diluted with water for thin washes and in this state they will still retain their permanence and adhesion.

Although the stiffness of the colours as they come from the tubes will normally allow the building up of quite heavy textures, this may be increased by mixing in inert additives. These can include kaolin, marble dust, whiting and fine hardwood sawdust, up to about a third of the volume of paint. If the painting is carried out thickly with a brush or a knife, acrylics have a distinct advantage over oils: they dry quickly and leave a durable and flexible film that is very unlikely to crack. Further, during the painting process it is quite safe to put one layer upon another recently laid layer, and there is no danger as with oils of this procedure causing cracking.

All colours in the range will dry at about the same speed. Thin washes will dry in a few minutes and heavy textures in about three to four hours, although they will be skin-dry in about half an hour. If you need the colours to dry more slowly, liquid retarder can be bought and mixed with them. Needless to say, it is important that the tubes should be kept well capped between painting sessions and folded up from the bottom to prevent air hardening the colour in them.

Acrylics should not be mixed on a wooden palette because, if they are allowed to dry out, the resin vehicle can adhere so strongly that the surface of the palette will be damaged. Therefore choose a palette made of a plastic, like formica, or use old plates, saucers, enamelled dishes or a multi-leaved paper palette from which the used sheets can be torn off and discarded.

Any type of brush may be used with these colours. What is important for the life of the brushes is that they must be cleaned very thoroughly after each painting

Page 17 top It is generally said that symmetry should be avoided in composition, yet here Meindert Hobbema exploits symmetry in this view of *The Avenue Middelharnis* in a way that shows a skilful artist can break any rule.

Page 17 bottom In composition, light and shade are as important as the objects being painted. In *An Experiment with the Air Pump* Joseph Wright of Derby uses light to create a dramatic effect which almost becomes the main subject of the composition.

16

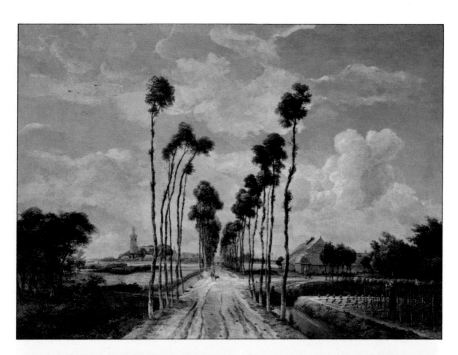

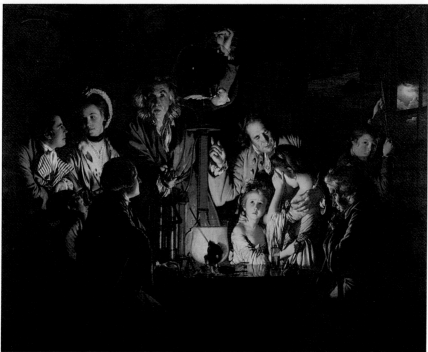

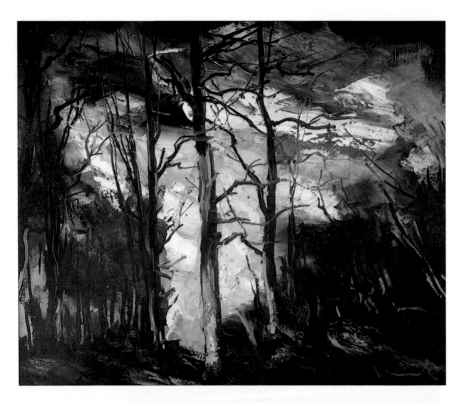

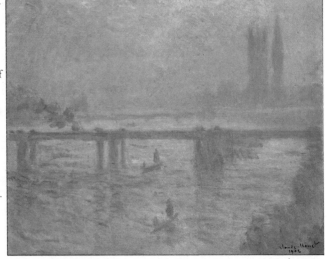

Two contrasting examples of the individual 'handwriting' that develops in the way the artist applies the paint. Above, the wild, excited brush strokes of Maurice de Vlaminck's *The Storm in the Forest*, below, Claude Monet's calm and delicate rendering of *Charing Cross Bridge*, the colour gently smudged into place to recreate that misty evening light the French call 'crépuscule'.

session. As long as the paint is still moist, this can be done quite easily by stirring around in clean water. A little pure soap can help, but the brushes should be thoroughly rinsed out afterwards. During painting, if a hog-bristle brush is to be laid aside for a short interval it can be left standing in a jar of water; if the brush is made of hair, it may be covered with a damp cloth. Should a brush unfortunately be left to dry out whilst still holding colour, it will have to be cleaned by being left to stand in a little methylated spirits for about half an hour; then it should be rinsed and washed as above. This should only be done in an emergency because such treatment could loosen the setting of the bristles or hairs.

Some of the brighter colours – cadmiums, blues and crimson – and also umber, may tend to dry out slightly 'down' in tint and tone. This can be rectified, if desired, by brushing over with acrylic gloss medium when the painted surface has hardened.

On an economy note, cheaper dry powder colours or decorators' powder colours can be mixed satisfactorily with one or other of the liquid acrylic mediums to produce a workable set of paints. Because the dried colours are elastic, this approach can considerably reduce the cost of painting stage scenery.

Equipment and materials

Drawing-boards and easels

Both can be regarded as permanent equipment, and thus care should be taken in their selection. A little extra spent on these two will be amply repaid by reliable service.

The choice of a drawing-board is comparatively simple. In the early stages, a piece of flat plank can serve, but it is best to graduate as soon as possible to a board of well-seasoned timber with a straight grain and battened at each end to prevent warping from the many dampings it will receive. Don't fall for saving money with hardboard or three-ply boards; these, even if battened, are seldom successful for long. If you are working on a large scale, the board will be cumbersome to carry. Fixing a folding handle in the middle of the back will help considerably. Protection for the board-face and a painting being worked on can be given by fixing a piece of waterproof canvas at the top edge of the back large enough to wrap right over the front and be tied in position with sturdy tapes.

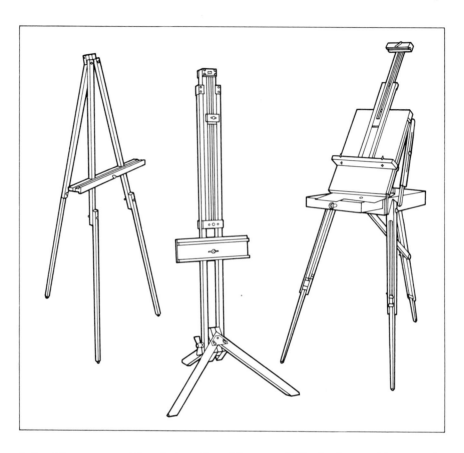

Left to right
A sketching easel,
studio easel and
box easel.

The choice of easel is more difficult. An easel is certainly going to be needed because you are not going to be able to paint in any sort of comfort with the canvas propped up against a pile of books, or leant against some rocks or a tree trunk when you are outside. A light sketching easel that will hold a canvas securely up to a size of around 60 × 50 cm (24 × 20 in.) and will allow some adjustment to position will cost somewhere in the region of ten pounds. Large studio easels that will take canvases 2 metres (6 ft.) high and move up and down by worm screw with a handle and have a full tilt are now extremely expensive – even if you can find them. Lighter studio models are quite reliable and will stand firm on their three legs. Perhaps a very convenient answer is in the middle range. A well-made combination easel and paint box of hardwood will give at least thirty years' service – I know because I have one. This type will carry all the tubes, small bottles,

brushes and knives in a drawer, hold a canvas up to at least 76 cm (30 in.) high and may be worked at in a standing position for oils or acrylic, or it may be lowered to allow the painter to sit for water colour.

Brushes

Brief mention has been made of suitable brushes under the various media above. There are three basic shapes that will be most often found: the round, the flat (or chisel shape) and the filbert, which is a mixture of the flat and round. Other shapes that may be met with and which have somewhat specialised uses are: the long-haired rigger, for detail work with acrylics or oils; the sword, which is a flat but has the bristles cut off at an angle of about forty-five degrees and which serves well for long, sweeping, curved lines; the sweetener with the hairs or bristles

Top to bottom The main brush shapes: round, flat, filbert, sword, rigger, mop, sweetener.

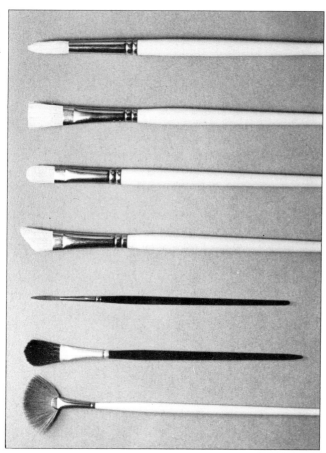

set in the shape of a fan, which is useful for the gentle blending of areas of colour; and then there are large, soft-hair mop brushes, either round or flat, that are used for laying large areas of water-colour wash and sometimes for glazing. If you are working specifically in oils or acrylics, a flat, white, hog-bristle brush about 2·5 cm (1 in.) or more wide will be called for when varnishing.

Brushes are becoming more and more expensive, and therefore the materials used should be understood. The source of hog bristles is self-explanatory. Synthetic fibres are being used increasingly for simulating bristle brushes, and the best will work very well. The cheaper varieties of soft-hair brushes are made from animals such as pony, squirrel, ring-cat or ox, whereas the finest are made entirely from Kolinsky sable. The high-quality ones will be high-priced but are worth the money for they will greatly outlast the others, will retain their shape and can be relied on to do just what is required of them.

Care for your brushes, whether they are of hog bristle, synthetic material or hair, and never put them away clogged with colour; after washing gently, set them to their intended shape by drawing them carefully through the finger-tips. Avoid vicious, harsh, scrubbing strokes, particularly when working on a rough canvas, paper or card. When putting them away for a period, either leave them up-ended in a jar or, if they are to be in a drawer, fit a small card or hardboard incline so that they will lie securely and there will be little danger of damaging the heads. As a protection against the larvae of the clothes moth, which are partial to hairs and bristles, place a small amount of repellent in the drawer.

Palette and painting knives

Palette knives are not really intended for painting; their purpose is to scrape excess colour from the palette and thus they tend to be somewhat stiffer than painting knives. The latter should be of high-quality steel and thin enough to be sensitive to the feel of the paint and the touch of the painter's hand. They come in a number of shapes from quite small ovals to diamonds, hearts and wedges. When buying them, be sure that there is sufficient crank in the handles to keep the knuckles clear of the paint surface and also that the blades are really pliable. As with brushes, they should be kept scrupulously clean. Hardened paint is best removed by a soaking in a paint remover, not by abrasion with a coarse sandpaper.

Two shapes of painting knife and below, two palette knives.

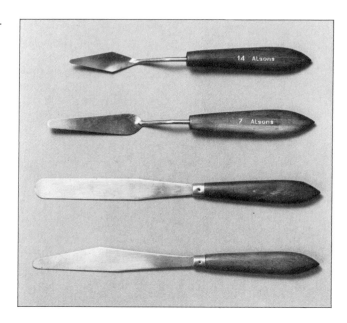

Mahlstick This is a length of bamboo or dowel rod that has a chamois-covered pad on one end. It is used to steady the hand when working on fine details. It may quite easily be made at home.

Mediums *Copal oil:* for oils, it can increase the speed of drying and give a certain enrichment.

Megilp: for oils, it is a mixture of light-drying oil and mastic, and has the appearance of a slack jelly. Care should be taken not to mix too high a percentage with the colours, or cracking and other undesirable characteristics may appear.

Papoma: a medium for oils composed of purified poppy oil, mastic and other oils.

Glasfyx: intended as a medium for oil colours if they are being used to paint on glass or porcelain.

Gum water: a solution of gum arabic which, when mixed with water colours, can give added transparency; it may also be used as a kind of varnish over the surface of water colours or gouaches.

Ox-gall: may be added to water colours to increase fluidity. If working with large, wet washes it can be beneficial to brush this over the paper before a start is made.

Turck's aquarella: medium for water-colour work on fine fabrics; it discourages 'bleeding'.

23

Varnishes

Although these are mainly intended for oil paintings, there may be times when particular types of varnish can be used with acrylics, gouache, tempera and even water colour. The principal varnishes that have been used are these:

Copal: a natural resin varnish made by dissolving gum copal with heat in drying oil thinned with turpentine. Some painters seeking a very rich look may use copal as a medium. The resulting film can have a high gloss, but is inclined to be brittle. It can also have a slightly dark, yellow-brown tone.

Dammar: prepared by dissolving the resin in gum spirits of turpentine. It is the clearest of the three natural resin varnishes, not so brittle as copal and can be a reliable finish for oils.

Picture mastic: gum mastic dissolved in gum spirits of turpentine. It may also be used as a medium for oil painting.

Synthetic resins: these are normally water-clear and, having a plasticiser mixed with them, are less likely to crack than the natural resin varnishes; also they will resist 'bloom', that misty appearance that may be found in paintings varnished some time ago.

Retouching varnish: can be prepared by thinning down one of the natural resin varnishes or synthetics; readily available in bottles and aerosols.

Wax: pastes composed of a mixture of beeswax with turpentine or turpentine substitute. They give quite a pleasing matt finish.

Paper: specially prepared for use on maps, prints, drawings and with some mixed-media water-colour techniques.

Poster and water colour: water-clear for use on poster, gouache and water-colour work.

White lac: solution of the palest bleached shellac in methylated spirits. It will bring up the surface of a gold bronze powder on a picture frame.

White hard: thin varnish suitable for paper or cards. Clear and quick-drying.

2 Composition

In the history of painting there have probably been more theories and ideas about composition than in any other branch of art. As a painter faced with a model – whether it is an arrangement of objects for a 'still life', a bowl of flowers, a human figure, an interior or a landscape – you must first solve the problem of just what you want to say about it. Basically, composition is the placing of the principal shapes and masses in a picture. Rigid sets of rules may help one person but may equally frighten off another. A painting, when viewed, should generate a sense of interest and, to a degree, harmony in the eye of the viewer. The eye should be drawn into the picture. Composition starts as a mental process which can be encouraged by studying the works of others – studying only, not necessarily copying. To find the joy in your work, every aspect should eventually express your own individuality.

Face a blank canvas or sheet of paper and you are meeting a challenge. Painting is the act of transferring a three-dimensional vision of the eyes and mind on to a two-dimensional plane and maintaining the sensation of depth. Whatever the subject, the first action is selection. Just how much of what stands in front of one will be included in the picture? Don't be in a hurry to rush those first strokes. Devote a concentrated period of study to an analysis of the model. It may be helpful at the start to half-close the eyes. This will partly obliterate many of the fussy details and reduce everything to the principal masses. Get these down right and you can be well on the way to a safe foundation from which to build up the rest of your painting.

There are several devices to assist in deciding where to place the borders of the composition. The simplest is to

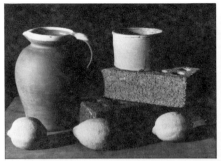
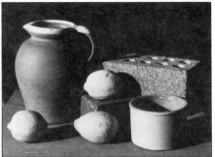
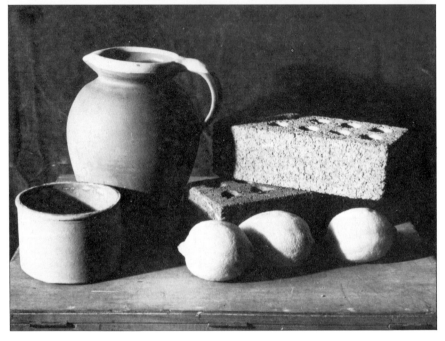

hold up both hands, with the thumbs outstretched, so as to form a rough rectangle with an open top. By moving this around between your eye and the scene you will start to find that harmony of enclosed forms which you are seeking. Another way is to cut out a rectangle, with the same proportions as the paper or canvas, from a piece of stiff card; and a third method is to cut out two large 'L's, which can be manoeuvred together, in and out, to frame up a rectangle of any proportions.

It can be helpful, when starting, to follow just a few guide lines. The grouping of the main items should not be too small within the rectangle of the picture giving the

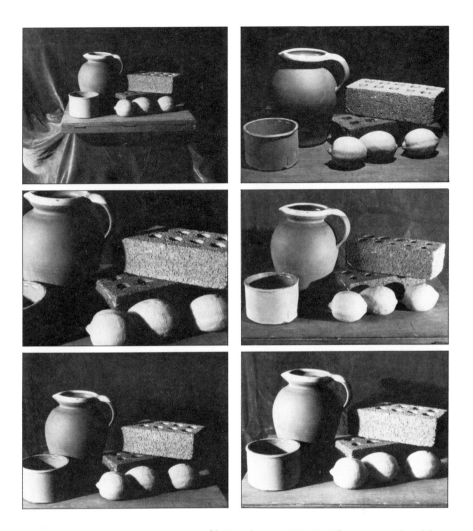

Above left Be sure that the objects 'sit' comfortably within the rectangle of your picture. Do not make them too small or too large, and avoid an unbalanced composition. *Above right* Remember, light is an important part of composition; changing its direction can make the same group of objects appear quite different.

appearance of being lost and insignificant; nor should these items be allowed to overfill the canvas or paper and thus possibly give the impression that the picture has been cut down. Get the placing and proportion so that you can sense for yourself that there is a concordant whole coming into being. Avoid placing a large mass that dominates the picture too much to one side so that you are left with a feeling of an unbalanced void on the other. With landscapes, watch the placing of the skyline or horizon; try to avoid having it in a position which is at variance with the scene being portrayed. Generally, for a seascape with an open view the line is best kept fairly low; when working

from a height in the hills or on a plain the horizon should be farther up. Try to avoid cutting any composition in half horizontally with a central line, or vertically by placing an important feature such as a tall tree or column right in the middle. One might almost say that symmetry should be avoided, and then one remembers how cleverly it is handled by the Dutchman, Meindert Hobbema, in that entrancing vista of his, *The Avenue, Middelharnis*. Often, by great subtlety, painters can tread over rulings that try to lay down patterns for practically every aspect of composition building.

When working on any subject, the use of a sketchbook can very often be a great help. Many artists always carry one around with them, as you never know when you are going to meet that unrepeatable moment or effect. Let it pass unrecorded and you will be in the same position as a writer who hears a phrase forming in his mind and then lets it slip into oblivion. A sketchbook, which need not be very big – somewhere about 13 × 18 cm (5 × 7 in.), so that it will fit into your pocket or handbag – and a reasonably soft pencil is all you require at the start. If you feel the need for a little colour, there are some very small paint boxes that will fit in well beside the sketchbook. Add one of those soft-hair brushes that unscrew from their handle and can be reversed and screwed back into it for carrying, and a small bottle of water, and you will be equipped. It is surprising how much vigour and truth can often be captured in one of those small, happy-go-lucky, quick sketches. Just a minimum of lines and perhaps a few dashes of colour and you have all that is necessary for the creation of a larger painting. The transformation can be done freely with the eye, or the sketch can be 'squared up' and the principal lines and features transferred to a canvas or bigger sheet of paper which has been marked out in correspondingly larger squares. The hardest part of all is not the almost geometric transfer but a much more elusive matter – that of taking across the sensation of life and freedom that was caught in those few brief moments when the scene hit the eye.

After composition come light and shade, although in fact they are both really part of it, for areas of both are just as important as any of the material features shown. A block of shade or splash of light has as much solidity, as far as the picture plane is concerned, as a mass of rock or a rugged building. Without light in particular, everything

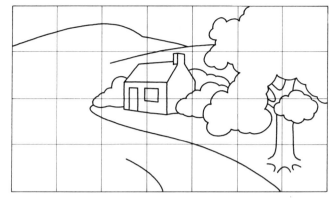

just passes into a nebulous, disordered scene; colour fades, texture becomes almost nothing. It is light which brings the life that we are trying to capture; it creates tone values and heightens the tints, it enriches what it passes over, it can lend mystery, enhance excitement, and its effects must be very carefully observed or they may be lost.

Likewise, the shadows need study, possibly even more than the highlights. Shadows that are just hard lumps of dark colour will say nothing and can well mar an otherwise well-painted area. Observe how masters in the vein of Rembrandt handle their areas of shadow. They do not forget that there are details to be indicated in those shades. The tone values need 'feeling for' with care. This handling of light and shade is termed *chiaroscuro,* and has proved a fascination for many painters. Men such as Caravaggio, La Tour, and Joseph Wright of Derby spent much time in exploring the ways of light, both natural and artificial.

It may need much practice to enable one to see not just the primary areas of light and shade but all those almost infinite nuances of reflected light, transmitted light, and subtle features of light that seem to creep round objects such as tree trunks, cylindrical pots and columns, on the opposite side to the light source. Look and look again to seek out the half-tones, the softness of that exquisite early dawn or evening light that the French call *crépuscule,* moments when the landscape almost appears to be melting away into the night – surely one of the most difficult problems, for you will have time to do little more than put down some painterly 'shorthand' notes about what you feel the colours are, and after that you will be on your own with your memory.

29

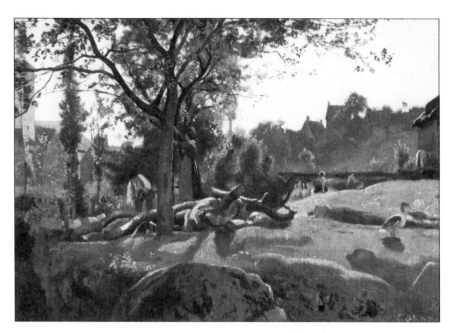

The subtle art of indication. Although this painting by Jean Baptiste Corot of *Peasants under Trees at Dawn* appears very realistic and detailed, on closer inspection the treatment is seen to be quite broad. The figure of the girl sitting on the river bank, for instance, is suggested with just a few deft strokes, and the background foliage and buildings are treated even more simply. Realism is achieved not by painstaking detail but by accurate tonal relationships.

Jean Baptiste Camille Corot was an adept at capturing that magic of receding day. Examine one of his paintings and note how broad the treatment can be. The foliage of trees is suggested by a few strokes; there will be few if any hard lines. The latter point is a good one to hold in mind with whatever subject you are dealing. Start putting things down on the paper or canvas with a lot of tight, crisp, hard lines and it will be odds on that the freedom, vitality and emotion you are trying to capture will escape you, and will not be imprisoned in this cage.

Look at nature, whether it is a plant in a pot, the interior of of a castle, a landscape or seascape. How many hard lines can you really see? Try to put down form with clear-cut edges and probably the best you will achieve will be just a cut-out, a flat shape with no anatomy, no feeling of depth or modelling. To convince yourself, paint in an earthenware jug with strong crisp strokes, outlines; then whilst the paint is still moist, rub down those lines with a fingertip, soften them, and then stand back and look at the semblance of rounded form that will start to emerge. If you try to forget outlines, it can help immeasurably. Nature doesn't really have them at all; areas of colour, forms, yes – but not constricting lines that can bind up and tighten the whole picture.

When working with interiors and landscapes another problem comes up. This is, how to give the appearance of depth to rooms, buildings and other features. Study paintings by the early Egyptians and even those of later centuries leading up to the Renaissance. Many of these have a strange, flattened-out appearance; the details may have a realistic look, but the whole does not read in a natural way. The artists may have wanted to give a feeling of depth, the 'third' dimension, but they had not yet discovered the way to put their pictures into perspective. Although the Romans had used a form of perspective, the art was lost and was not rediscovered for some centuries. Various painters experimented with ideas to solve this problem. The Italians, Masaccio, Donatello and Uccello, and the great German artist, Dürer, made their contributions until the geometric basis of this third-dimension effect was established step by step.

The painter does not have to get caught up with all the mathematical complexities of perspective that the architect or draughtsman would use. However, to capture the sense of reality, a few basic points need to be understood. In the same way that in an anatomical painting the bones should be there under the flesh and muscles, the correct lines of perspective should underlie a landscape or interior. Some would reject the rules of perspective and others might take them to the limit and produce a forced *trompe l'œil,* which is designed to give the objects a totally real appearance, to 'deceive the eye'. Again, make the decision for yourself. Have a look at how such people as Canaletto, Watteau, Gainsborough, Constable, Turner, the Impressionists, Sickert and others of this century have solved the

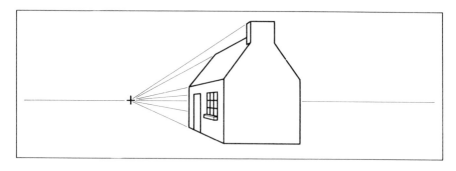

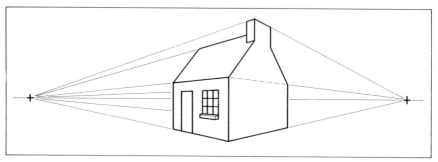

problems with their individual interpretations. The suggestion of that third dimension may only need the lightest indication, but it should be right.

With pictorial perspective, a horizon line is established and on this line are set one or two vanishing points. These are imaginary points to which vertical and horizontal planes and horizontal lines converge to give a feeling of recession or vanishing towards the distance. The simplest form of perspective is where there is a single vanishing point somewhere on the horizon line within the picture area. By moving this point along the line or raising or lowering the line, different aspects can be achieved. One vanishing point can be satisfactory for interiors, but may give a somewhat stilted and forced look for buildings in a landscape. To achieve a more naturalistic look, it is better to use two vanishing points. Both of these will be on the horizon line but will be outside the picture area, one to the right and the other to the left. From these points the various lines and planes will be produced according to the angle at which they are set.

All this may sound complicated, but it is hoped that the small sketches will clarify the bones of the subject. A little practice on rough sheets of paper will soon give the feel of

For interior perspective, one vanishing point is usually sufficient. Changing its position alters the view of the room.

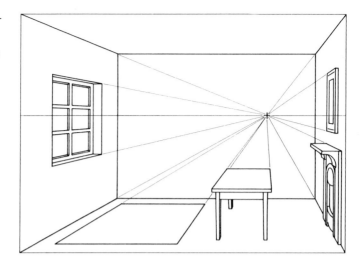

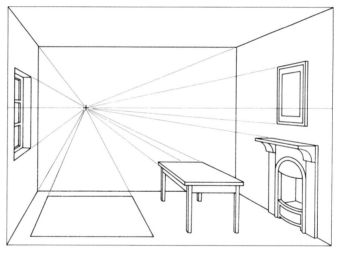

these lines going away to the imaginary points, and the results will give a solidity to the buildings and other features. A simple aid when working on a scene is to hold up a brush so that it lies along the particular line being tackled and then drop it down so that it lies across the paper or canvas, at the same angle. In a similar manner the handle of the brush can be used for taking rough measurements of different features. Hold the brush up against the selected detail and mark with the thumb where the measurement comes and, as before, drop to the picture. Actually, as progress is made you may find that

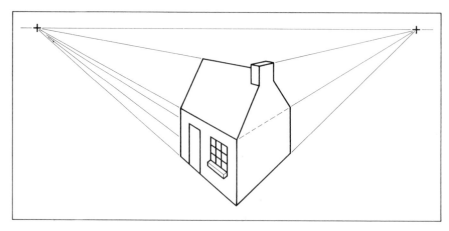

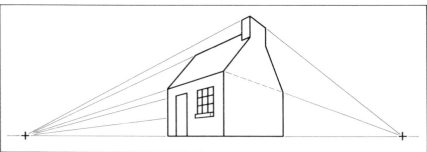

Top bird's eye view, *above* worm's eye.

much of this feeling for perspective and size can become an almost automatic part of the painting process.

There are two other types of perspective, known as 'bird's eye' and 'worm's eye'. The first is used when it is desired to give the impression of looking down on something – for example, when painting a scene of a village from a viewpoint on a hill. The horizon line with the vanishing points is carried high up in the picture, and again the lines and the planes will converge to the requisite points. 'Worm's eye' will give the impression of viewing a scene actually from ground level; the horizon and vanishing points are dropped right down to the bottom of the picture and the lines and planes produced as before.

One last point with this business of the third dimension: circles, arches and semicircles need a little care to get them to look right. They will not appear either vertically or horizontally as perfect circles or curves; they adopt the shape of an ellipse. If in doubt when painting the arch of a bridge or doorway, or an ornamental round pond, for

Right This painting of
*The Birth of John the
Baptist* by the fifteenth-
century painter
Giovanni di Paolo
shows how medieval
artists struggled to
introduce some effect
of perspective into
their work.

Below Two hundred
years later the prob-
lems of perspective
were completely solved.
Jan van der Heyden's
View in Cologne is
a bravura example of
two-point perspective.

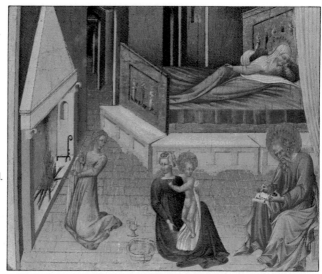

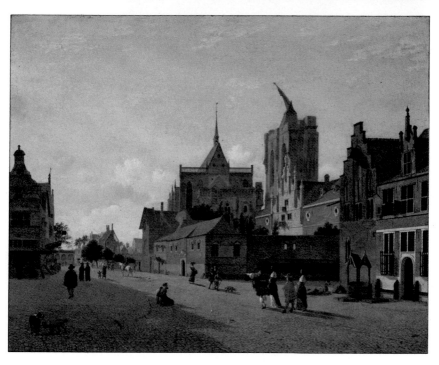

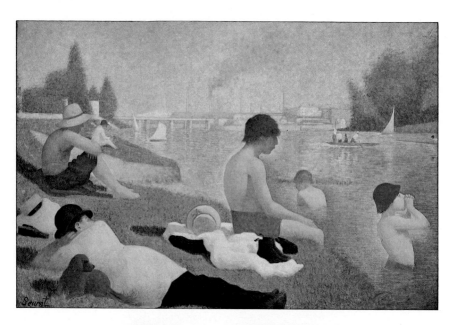

Georges Seurat was a pioneer of a method of painting which created subtle colour effects by breaking areas down into bright flecks of pure colour which were fused together in the eye. Close examin-ation of one of his paintings like the *Bathers at Asnières* shows that the green grass, for example, also picks up the blue of the sky and the colours of nearby objects. Shadow areas often contain flecks of the colour that is complementary to the highlights. (See page 45) The grey shadow of a white shirt is in fact a fusion of blues and pinks.

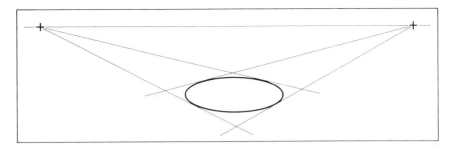

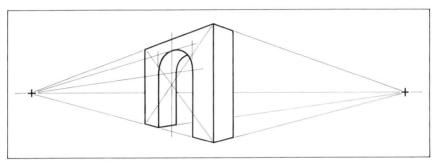

Constructing a horizontal circle and an arch in perspective.

example, first of all lightly indicate the square or rectangle in perspective that would contain the feature, then fit the ellipse of the arch or pond into this square or rectangle.

There is something else that should be thought of here: licence for the artist. In a dictionary under the entry for 'licence' can be found definitions such as: 'liberty of action or thought, freedom'. The term 'artist's licence' should, I think, be taken in just these ways. If you feel you don't want to put in certain features in a picture, don't. It is your painting, your individual reaction to what is in front of you. Nothing can be so restricting and frustrating as to feel duty-bound to put in every petal and leaf with a flower painting, or to place every brick and tile slavishly in position with a landscape. Take what you see of the still life group or landscape, and use just what inspires or excites you in the composition. Examine a scene by Sisley that appeals by its sheer realism. Go close enough to pick up the brush strokes and what from a distance of a few paces looks as if it has everything, dissolves into a seeming confusion of colour, texture and restless strokes. This is the legerdemain or magic, if you like, of the master, who can create this state on the canvas or paper which, when viewed from a distance, has all the virile life of an emotional realism – more so, much more so than if a rigid,

minutely observed rendition is made. Observe the hands in some of the portraits by Frans Hals, the eyes by masters such as John; close examination reveals that in actuality they are brushed in with a minimum of strokes yet still give the desired effect. Look closely at a landscape by Turner when he was working in what can be called his 'atmospheric mood' and see how he has created many impressions with a skilful simplicity. These features all point towards a very important fact that underlies so much painting, and this is the great art of indication. It is all bound up with that 'licence'. A flick of a brush stroke can become a figure in the mid-distance. Have a look at a painting by Francesco Guardi where there are groups of people, and see how small specks of paint are put on to indicate figures. A brush stroke of a petal by Emil Nolde vividly brings to life a flagrant red poppy. A single brush stroke put down on the canvas will draw or indicate a feature as effectively as any more laboured method and will be likely to have a great deal more life to it.

Whatever is done on the way whilst painting is your personal affair, the result will be judged by the final effect.

3 Colour

In chapter one it was mentioned that you could be faced with more than a hundred colours from which to choose. If the lists of the various makers are all put together, the total number of different tints and tones available rises to not much short of two hundred. From this great range how do you make your choice? Certainly when making a start, a short list should be selected; with a restricted range of colours it will be simpler to control the harmonies, and by mixing and intermixing you will be able to understand and get to know just what these colours can do better than if you went wild and came away from the art shop laden down with a vast number and much the lighter in pocket.

One of the great colourists, Titian, is recorded as using no more than seven colours with lead white and ivory black; his palette was genuine ultramarine, madder lake, burnt sienna, malachite green, yellow ochre, red ochre and orpiment (also known as king's yellow, extremely poisonous, unreliable, and now obsolete, having been replaced by cadmium yellow).

Other masters worked from an even smaller palette; the selection of colours might vary depending on the subject. So, which collection will give you the widest scope and at the same time be manageable? The following colours will provide plenty of scope for experimentation, but they are suggested purely as a basis. After experience is gained, it may well be that some may be discarded and others added.

Eight basic colours

Yellow ochre Native earth, pleasant dull yellow tint, opaque and completely permanent; it has been used continuously since prehistoric times. With French ultramarine it makes cool

greens; with light red a variety of brick and tile shades can be achieved.

Cadmium yellow

Powerful rich bright pigment which will produce strong oranges when mixed with cadmium red, and a range of luscious greens with French ultramarine.

Cadmium red

Brilliant strong pigment which replaces vermilion. With French ultramarine it produces a range of purples and mauves for some flower work; with burnt umber and cadmium yellow it makes a variety of warm browns.

Light red

Useful dull red; broken with white it gives subtle pinks; with burnt umber, tints for pine trunks; with alizarin crimson tones for rusted metalwork.

Alizarin crimson

A warm, strong colour that replaces earlier, similar tints that were not always permanent. Useful with morning or evening skies, with flower work, and also for depth of shade with interiors; mixed with French ultramarine it produces a very deep, strong colour.

French ultramarine

An artificial colour first made about 1828, which has supplanted true ultramarine, mainly for economic reasons. Strong, clear pigment for skies and making greens with either of the yellows; with burnt umber plus a little alizarin crimson it makes a tint so dark that it can almost be used for black.

Oxide of chromium

A cool green that has many uses, especially for flower and tree foliage, and seascapes; mixed with the yellows makes a wide variety of bright and soft greens.

Burnt umber

Calcined raw umber. Sound strong pigment that, as part of a mix with other colours, can be the foundation for many areas of work: stonework, thatch, tree-trunks, soil, ironwork and dark objects in deep shade.

The choice of white can be from flake, titanium and zinc. You may well feel happier with titanium, the most recently introduced white pigment, which is a very good coverer, non-poisonous and works well with all media.

If you are painting with acrylics or oils, a larger tube of white will be needed than of the other colours. This is because, with both these techniques, white is often used to

break the strength of the main palette colours rather in the way water is used to dilute water colours.

If you are starting from scratch, be prepared to spend a few hours becoming intimate with the colours suggested. Provide several sheets of rough paper and pieces of cardboard that have been primed. Range over the whole selection of colours and try out intermixes between all of them, even if you might feel a little doubtful about a particular combination; often some quite unsuspected tints can emerge. The object of this is to gain experience not just with intermixing the pigments but also by noting the effects of various mixes with different amounts of white. It will be seen that some colours may seem to change their nature as the amounts of white are increased. Having brushed around with whichever medium you have chosen and got the feel of colour mixing, you will probably have noticed, particularly with oils and acrylics, that if the mixture is stirred too much the brightness of the resulting tint appears to drop. This points to the fact that as far as possible all colour mixings should be done as directly as possible and with as little puddling about with the brush as can be managed. Each attempt will widen your experience and make it more likely that you will be able to match a colour when a start is made on a model. It can be a fascinating challenge to look at an old warm-coloured earthenware pot and try to catch its subtlety; you may want to start with light red and then add small amounts of cadmium red and alizarin crimson as your memory of past experiments tells you.

Greens can often be tricky. Are they on the cool side or warm? The light, time of day and the particular tree or plant are all factors to be considered. As advances are made, so it will be found that your power of observation will be honed up. The eye will not only be catching nuances of colour not seen before but will also be picking up more of the infinite variations of light and shade.

The science of colours – their origin, their effects one on another – has fascinated and excited painters throughout history. Volumes full of theories have appeared. Trials and errors have at times ruined many pictures that could have been masterpieces. For example, in the eighteenth and nineteenth centuries a number of painters such as Sir Joshua Reynolds, John Hoppner and David Wilkie chose to use asphaltum, a blackish brown colour. They found that it gave them a depth of warm tone and a harmony for

shaded areas, and it also seemed ideal for glazing. But it was to prove a misleading temptress. Asphaltum dries badly. It can cause wrinkling and cracking, and will readily 'bleed' into nearby colours, and can in some cases combine with the varnish either forming segregated lumps or slowly dribbling down the canvas. Reynolds, in particular, favoured its use, and a picture of his that has a lot of the colour may be almost impossible to save. This has been spelt out at some length to underline the fact that you shouldn't experiment with the unknown. Do not use oils, spirits and other mediums with whatever media you are working unless they have been specifically recommended by the artist's colourmen; after all, why not use the 'know-how' that the experts have built up over the centuries?

In the latter part of the nineteenth century there came a revolution with the use of colour that appeared to erase many of the theories that had been held before. The French Impressionists saw that colours applied to a canvas in a certain way could present the idea intended equally well as a carefully drawn outline. Whereas before this time it was line that had held the highest degree of significance, these artists and others following them now began to see colour as all important – but still, of course, laid over basically correct construction, composition and drawing. The effects of placing one pure colour or secondary mix beside another were studied by working from a scheme of laying complementaries alongside each other. In the simplest sense this means putting a primary colour beside a secondary colour, a contrasting hue against which it will stand out and produce the most striking and richest effect. Primary colours – red, yellow and blue – mixed together give the secondaries – orange, green and purple. Put these colours down in a simple circle and you have yellow, orange, red, purple, blue and green. The ones opposite in this circle are complementary. Thus red and green, yellow and purple, and blue and orange are pairs of complementaries.

Study a work by Van Gogh, and it can be noted how this theory of complementary colours can really be exploited. Contrasts of intensity and sheer colour excitement can be achieved that were not thought possible before. Part of this effect is due to the formation of an after-image that is, for a moment, visually retained. The eye views one colour which is partially held when the eye

passes to the next colour, and creates an intensification of, or contrast between, the two colours. Naturally, when viewing a picture one does not examine small portions at a time but rather appraises the whole, yet this after-image reflex is working in the background. Seurat, the Pointillist, took matters further when he placed small specks of pure colours alongside each other without any line indication at all, relying on the eye of the viewer to mix the colours from which the forms he intended would appear.

When handling colours, be sure that you have reached some understanding of harmony and, in particular, discord. Both of these features are difficult to explain because they are largely individual experiences and reactions to particular colour situations. Discord in nature is a rarity, or perhaps does not happen at all. But it can easily result, if tints and tones are put down next to each other which set up unpleasant 'vibes'. The solution here is really a personal one, for reaction to colour is a highly intimate matter that will probably bring its own solution with practice. As the colours are used more and more, it will be found that a harmony of mind will almost inevitably make itself felt through the brush and palette on to the picture.

In the preceding chapter the use of perspective to give depth to the painting was explained; this seeking for the third dimension can also be assisted by the choice of colours and tones that suggest recession. Observe a landscape carefully, and in general the bright, warm, strong colours will be in the foreground and the soft, cool tints will be in the distance. If you are looking at a smooth plain reaching away from you towards the horizon, a subtle change can be noted as it moves towards the distance. Immediately in front of your easel the grass will be luscious and bright green, probably calling for cadmium yellow aplenty; then gradually, as it moves away, the intensity and strength will come down, needing yellow ochre; and further and further away, more French ultramarine, more white; and perhaps at the extreme distance, just a touch of alizarin crimson. Some painters become so obsessed with the physical pleasure of the richness and glittering strength of cadmium yellow or cadmium red that they cannot resist going on using them even when the bright flowers or painted hulls of boats are away in the distance. They then wonder why these objects won't visually stay in place. There just is no way a full-blooded stroke of full-power pigment is going to sit hap-

pily in a spot intended to be a mile away; it will be trying everlastingly to jump into the foreground.

To get the maximum joy from the canvas, don't cover the whole ground with an over-rich assembly of colours. The main bright areas need some subdued tints and tones around them to be able really to 'sing'. There is a splendid, infinite area here for exploration. Used with understanding, colour can be the most thrilling experience. Flowers offer the chance for an acute study of just what is possible. For a day at least they will stay as an inspiration, unlike the usually constantly changing landscape. The intensity of some 'passages' can be almost physically felt. Deep red roses giving their all against a soft grey-green; the pungent purple of irises pulsating out from yellow ochre; the pure, almost ethereal, whiteness of a cyclamen's flowers set against the cool greens of those round, slightly heart-shaped leaves and a very dark background. The adventure into this wonderful world of colour which you can manipulate with brushes can be splendid.

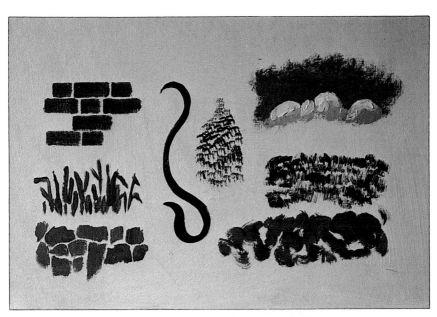

Above Examples of various kinds of strokes made with different brushes. Left, a flat brush can 'draw' the bricks of a wall in short strokes, or can be used on edge to make reed-like marks. Centre, a filbert brush is useful for long flowing strokes, piling up thick layers of paint and producing interesting textures. Right, a round brush is good for round shapes like bubbly clouds and can be used to stipple on textures.

Right A colour wheel made up of the three primary colours, red, yellow and blue, with the secondary colours, orange, green and purple produced by mixing the primaries. Colours on opposite sides of the wheel are complementary.

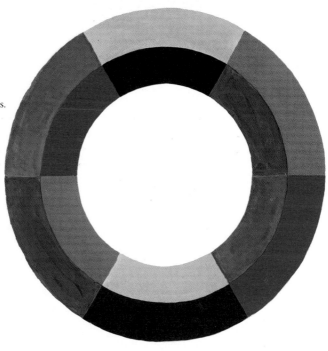

The four main stages of a painting

Canvas with an 'imprimatura' of weak burnt umber and the subject drawn in roughly with a mixture of burnt umber and French ultramarine.

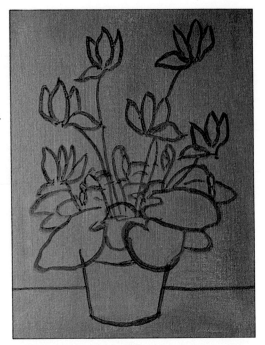

The background added with broad strokes of a flat brush. The direction of the light is emphasised by lightening the background towards the light source.

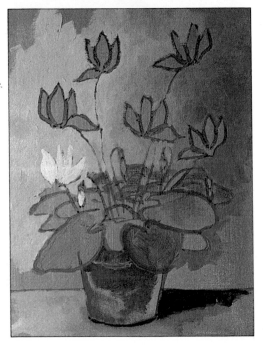

The main colour and tone masses of the subject stroked in boldly using a round brush for the leaves and a filbert for the flowers.

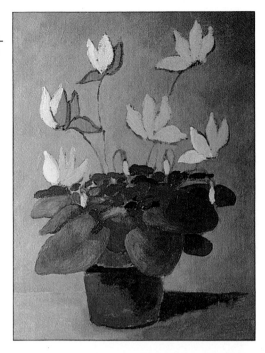

Fine details like stems added with a rigger. The leaves of the cyclamen given their distinctive character by smudging on a lighter colour with a finger tip, and using a 'sgraffito' technique to produce a crisp, serrated edge. A few flecks of brighter colour on the pot help to balance the composition by adding interest to the bottom of the picture.

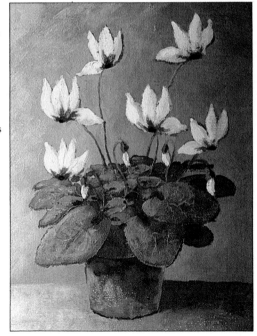

Yellow ochre Cadmium yellow Cadmium red Light red

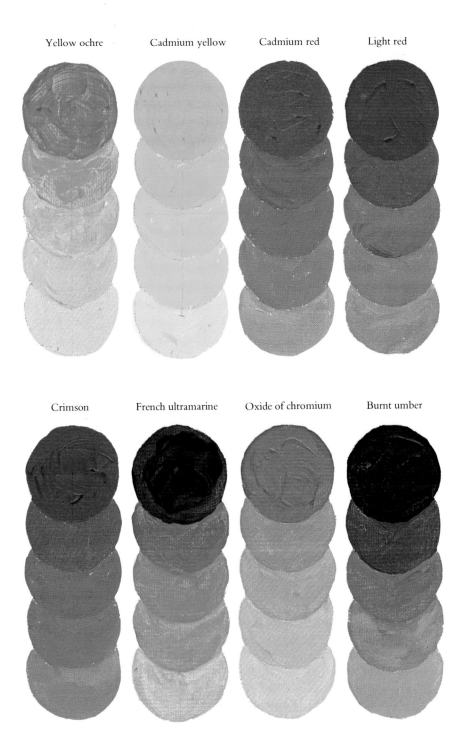

Crimson French ultramarine Oxide of chromium Burnt umber

4 Application and style

Freedom has been mentioned several times, and in many ways it is the all-important feature of painting. Glimpses of freedom shine out from the work of many artists of the past and of today: the bravura strokes of Rubens, the wonderful tempestuous sky over the city of Toledo by El Greco, the fluidity of the sketches by Constable, the warm, smudgy depths of a Sickert interior, or the seething movement achieved by Francis Bacon.

The first step for most is the drawing-in. How is this best to be accomplished? Studio rulings from the past may have suggested that everything should be carefully limned into place, by sharp-pointed pencil, pen-and-ink or charcoal, the last of which would then have to be sprayed with a fixative to prevent the lines smudging. Should you think you would be happier setting down these first outlines with a 2B, do so. But somehow to go straight in with the brush sets the pace and gives confidence for the work that will follow. Select a small round hog or a soft-hair and brace yourself for that moment of breaking through the barrier of uncertainty and fear as you dare to mark that virgin paper or canvas. Mix up small quantities of French ultramarine and burnt umber with plenty of turpentine substitute if you are working with oils or plenty of water for acrylics, gouache, water colour or tempera, so that you have a fairly light-toned, warm grey.

Page 48 A selection of eight colours which provides a good palette for the beginner. Notice how some colours seem to change in tint when they are 'broken down' with white to make them lighter in tone.

Now, stand back and take that long moment of study. Try to see where everything will go before it goes there. Mix on the palette; if you try to puddle colour around on the paper or canvas it won't work. Constructional lines can be corrected later, but some of the freshness will be lost if too many are wrong at the outset. Take the brush in the hand and hold it rather than grip it. Gripping could

49

signify tension, which is the last thing that there should be. Whether standing or sitting, work the brush from an arm moving freely from the shoulder. Try to avoid coming in close with the wrist resting on the support, or brush movement will be restricted to the fingers. Dip the brush in the prepared mix of French ultramarine and burnt umber, and then away into the drawing. Keep it simple, just the bare outlines of the main forms, and only indicate enough of the details to bolster your confidence. If an error is made when working with acrylics, it can be speedily removed with a rag moistened with water, or with oils, a rag dipped into turpentine substitute. A mistake with water colour can be taken out by gently stroking the area with a well-moistened brush and then dabbing, with clean, dry rags or blotting paper.

If the sight of a staring white canvas or panel is intimidating before beginning the drawing-in, lay an *imprimatura;* this is a thin veil of colour washed over the whole surface. It may be a weak burnt umber, or a mixture of yellow ochre and burnt umber; artists have used a number of varying tints including alizarin crimson for night work. The colours should be diluted with turpentine substitute when working with oil, and water when working with acrylics.

For water colour or gouache on heavy paper or pasteless board it will help the flow of the colours first of all to sponge over the working surface with ox-gall. The ensuing drawing-in should be done with strokes that are as pale as possible; they need to be definite enough to guide subsequent work, but faint enough to disappear under the build-up of washes.

In the chapter on colour, it was suggested that time should be taken to practise mixing; plenty of trials should also be made with different shaped brushes. Load them with colour and make a series of strokes holding them in a variety of ways: overhand, underhand, stippling straight down. The round variety can be made to produce many differently shaped strokes: specks, dabs, swirling lines, twisted, dragging and pointed. The flats can be made to simulate brick or stone work, and held on edge they will make sharp stabs for thick reeds. Again on edge, a well-loaded flat can put in palings in one flick. Filberts have a range of strokes that complement the other two. The long, soft-haired rigger, loaded with diluted colour, will trail lines for mooring ships, or slip in highlights on bur-

nished metal or glass. The sweetener can often do more to blend the bottom of an evening sky than any other shape; slightly moisten the tips of the hairs or bristles with a little oil or medium if working in oils, or water if using acrylics, and then, holding the brush flat and almost parallel to the panel or canvas, gently drag it across the surface of the freshly applied colours. The large round or flat mop brushes are best kept for water colour and should be handled with care as, owing to their size, they can be a little delicate.

The use of painting knives should also be practised. After a session of conventional work, use waste paint to try out varying strokes. Load just the edge of the knife with colour, lay it carefully down on a support, and a series of sharp ridges of colour can result. Dab the colour down, sweep it into position and then pat the knife into the colour; this will raise a prickly texture. Lay another flat area and work into it with the point of the knife, simulating blades of grass or undergrowth. This is a *sgraffito* technique that may also be carried out with the butt end of a brush handle. *Sgraffito* has many uses: constructional details with steelwork, thatch, the uppermost twigs of a tree in winter when the leaves are stripped. If a fairly strong colour has been laid as an underpainting, it can be effective to scratch back to this and expose some of the colour. The technique is suitable only for oils, acrylics, tempera and gouache. Similar treatments can be used with water colours to give the unexpected touch to an area of a painting. Coarse sandpaper can be drawn across dried colour to give an effect of sunlight streaming through a window or down between a gap in the clouds. An eraser may be used in the same way, but it will give a more gentle result. If you are working on a very heavy rag paper or pasteless board and an exceptionally bright highlight is called for, this may be put in with a razor blade or a surgeon's scalpel. First follow down the desired line with the blade held at an angle; then reverse the process from the other side so that a small piece of the paper comes away leaving a shallow 'V' cut.

With oils or acrylics the more or less traditional approach is to build up an underpainting, which places the main tonal areas but leaves them 'down' in colour compared with those of the finished layer. This underpainting, if in oils, should be thin and lean, and best diluted with turpentine, which will dry out fairly quickly. With

Right A latex masking solution may be painted over certain areas to isolate them from washes of colour applied once the latex has dried.

Far right When the colour is dry, the latex may be peeled off to reveal the virgin paper in sharp contrast to the background

Right Soft-edged light areas, like clouds, can be 'mopped out' of wet colour with cotton wool or paper tissues.

Far right Areas of wet paint will 'bleed' into each other. Here flecks of dark colour are allowed to bleed into the wet wash of the sky to give an impression of distant foliage.

Right 'Sgraffito' technique in which paint is scraped away to reveal a contrasting colour or tone underneath. This is useful for scratching in detail and creating interesting textures.

Far right The painting may be abraded with coarse sandpaper to give a rough texture suitable for the surface of rock, etc.

acrylics the colours can be diluted with water, or acrylic medium and water, to a proportion of about one part medium to three parts water. When these underpaintings have set dry, the finished paint can be applied. Oils and acrylics, where the paints are applied fairly thickly, rely to a degree on texture produced either by a brush or a painting knife. Here it can help to take a look at the way someone like Van Gogh, Chaim Soutine, Oskar Kokoschka or Maurice de Vlaminck works into his paint. Whatever you do with texture or brush and knife strokes, watch that you do not become too enamoured of a particularly successful stroke and go on repeating it until a whole area is reduced to monotony.

It is in this matter of brush and knife strokes that you will bring out your own personal manner; after a time a 'handwriting' that is yours and yours alone will emerge. As you work at a subject, endeavour to see that the various details can be transformed and transferred to the canvas or panel as single brush strokes or put in with a minimum of strokes to give the desired impression rather than try to depict them minutely. Paint to bring the whole picture along together, and don't be too enthusiastic about finishing some detail that attracts you in one corner. This may look fine on its own, but may be wrong when the rest of the picture is completed. Keep half-closing those eyes to assist in keeping things concordantly together in a broad manner. There can be plenty of time at the end to study just where it will help the most to put in those few finishing flicks of light or dark that can bring the whole painting to life.

Whatever medium you choose, in general, it is helpful to start with the areas farthest away: the back-drop for a still life or flowerpiece, the walls with an interior, or the sky and then the far distant hills with a landscape. Having said that, as Hobbema exploded the rule on symmetry, so there have been artists who have painted the trees first and then put the sky in between them. But it is simpler to follow a rule of farthest first and then work your way towards the foreground.

All the painting media can be and have been put on in many different ways by painters. Oils have been washed on greatly diluted with another oil or a spirit, acrylics can be heavily thinned with water, so can tempera and gouache. Water colour alone is pre-eminently suited just to a wash or thin application; most colours in this medium

are transparent to a high degree and rely on this delicate treatment. Despite its transparency and delicacy, in the hands of someone like Turner or Nolde, water colour can have every bit as much power as an oil.

With water-colour painting, the laying of a wash is a method that must be mastered at the outset. The paper chosen should be either stretched or stiff enough not to buckle when heavily moistened. The board on which you are working should be given a tilt of around five degrees. First mix up just one colour in a saucer or well palette; don't be niggardly, mix up plenty because once in the middle of a wash you cannot stop to make up further supplies. Thoroughly soak a mop brush in the colour and then drag it lightly across the edge of the container to remove some of the liquid. Start at the top of the paper and take the mop across and reload. The strokes should be more in the way of caresses than a definite, firm contact with the paper. Keep the colour running down the surface and avoid leaving any areas blank, because if you have to go back it is almost certain that it will show and mar the even quality of the wash. Take the colour right through the area intended for the picture and then swab away the excess. Having got that under control, now try for a graded wash. Have several wells in the palette filled with varying strengths of the colour chosen. Start at the top, as before, with the strongest tone, then as you proceed down the paper, feed in the lighter tones and finish with perhaps two strokes of pure water at the bottom. Variations in this grading can of course be made by bringing in other colours: for a sunset, strokes of previously mixed pale yellows and crimsons. Clouds can be dabbed out with blotting-paper or pieces of clean rag whilst the sky is still wet. One other ploy with large areas of washwork is to lay the board flat as soon as the basic wash has been applied and then, with a fairly large brush, to drop in other colours that can spread and, with luck, give a fair impression of clouds and other features.

With water colour, spend more time on thinking about the execution than with other media because it is next to impossible to remove a serious mistake; ugly rings can form and the essential crisp beauty of the beautiful transparent medium will be lost. A picture with a blemish can sometimes be saved by applying some treatment with opaque Chinese white, or by treating it as a gouache and using areas of thicker colour. A more extreme mode of

dealing with it is to immerse the painting totally in cold water, leave for a few minutes and then gently work at the offending area with a small, not too stiff nailbrush. If this is done, the immediate surrounds of the mistake should also be brushed, tapering the effect so that, hopefully, it will blend into a harmony.

To return to oils and acrylics, where the emphasis is largely on thicker paint, many painters today favour what is called *alla prima* as this can give them a greater sense of freedom than the more disciplined method of first putting on an underpainting. In this manner the artist works straight away on his primed canvas, with or without a previously laid *imprimatura*, with the intention that every stroke that is made will show and be a part of the finished painting. Here again, to encourage success, spend some considerable time studying the subject and working out in the mind just where the strokes will go and how the various areas will be treated. Direct attack is needed. It can be a challenge to the nerves, but the result, with its fresh colours and often dramatic texture, will be rewarding. If the odd blunder is made, wipe it off with a rag soaked in turpentine substitute for oils, or water for acrylics. Let the area dry out and then repair the *imprimatura* as best you can and proceed.

Heavily textured painting is termed *impasto*, and this thick work can be raised either with hog-bristle brushes or painting knives. It can be exciting, but one small note of caution: in work with oils, the thickness of paint should not exceed more than 5 mm (³/₁₆ in.) at most. The reason for this is that oil colours can take a very long time to dry out, and over-thick areas can be prone to cracking and what is called 'rivelling', a condition in which the paints exhibit an unsightly network of wrinkles. *Impasto* with acrylics can be thicker, as the vehicle in these colours is in itself a quick-drying adhesive. Brush and knife painting may be safely carried out up to a thickness of about 13 mm (½ in.) – the main limiting factor possibly being the cost of the colours used. As mentioned in chapter one, it is possible to mix additives to stiffen the acrylics further, and if this is done with care no impermanencies should occur.

For those who favour what is termed 'hard-edge' work acrylic paints will be found to be the most suitable. When slightly diluted to the consistency of double cream they will be found to brush on with considerable control and accuracy, and with little tendency to 'bleed' when laid

alongside each other while still moist. If long, continuous straight lines are called for with an abstract, these can first be masked with a special tape similar to that used by a commercial decorator, which can be bought from a paint shop or ironmonger. When the tape is down the colour can be brushed on and over the tape; when dry, the strips of tape can simply be pulled off. It is essential that the tapes should be carefully smoothed down before painting, otherwise there might be some leakage of the colour underneath them.

The term 'mixed media' will be met with, and it just implies the use of two or more different media on the same picture. This procedure does open up considerable possibilities for exciting and off-beat effects, but at the same time, if unwisely worked, can put at risk the finished picture. Certain combinations are safe: gouache and water colour, for instance, and to these can be added further combinations from pen, brush and ink, charcoal, chalk and pastel, although for permanence the last three should be fixed. When spraying with any fixative, do so from about 30 cm (1 ft.) away and use short bursts rather than one long one, otherwise the fixative may flood the charcoal, chalk or pastel and ruin everything. Candlewax or wax crayons may also be used, either under water colour, when they can give useful resist effects, or on top of the finished washwork.

Acrylic can be used with water colour, but each coat should be dry before the other is put on. If the acrylic is washed on thinly, pen and ink will take, as will wax crayons, but chalk and pastel will not be very happy on top of acrylics. Oils may be applied well diluted with turpentine substitute as thinly as water-colour washes, and pen-and-ink work can be incorporated either under or on top of the thin oil colour. Some artists have experimented with pastels on top of oils, but it is a highly dubious course.

The term 'glazing' has been used, and it is a method that can stand more exploration than it often receives. Literally, it is the application of a thin veil, normally of a transparent colour, over previously laid and dried-out work. It may also be attempted with non-transparent colours, but before doing this, try out the effect on a scrap of paper or canvas, as it could be rather misty. Many of the earlier masters made much use of glazing with oils, understanding the rich, translucent effects that would be realised. Yellow over crimson can induce a fiery appearance;

blue over green cools the colour down. Almost endless experiments can be tried, and each will add to the knowledge of exactly what colours can do to one another with varying ways of application. The mediums most suited for glazing with oils are turpentine, turpentine substitute, linseed or poppy oil, and various proprietary oil mediums that specify glazing with their instructions. Glazing with acrylics is also possible, and the colours may be diluted with either water or one of the acrylic mediums, depending on how fluid a glaze is required and also the surface finish sought.

There is one other method of application for oils and acrylics that is often overlooked. This is 'scumbling'. It may seem a rather vague term, but in principle it implies the brushing of opaque colour over an area of previously dried-out colour and then, whilst it is still slightly moist, wiping parts of the colour layer away with a rag. The moist colour may also be dabbed with brushes or scraped with knives. This exposing of the under-layers can give some unusual effects.

Brushes, knives and rags have been mentioned, but sometimes none of these will serve to give just the right effect. What else should you try? Why not what most painters have used at one time or another – fingers? A small flick with the tip of a little finger can often blend in an area; a sweep with a flattened knuckle can do likewise; a light stroke with the ball of the thumb can soften an angry patch. Memo – wash the hands well afterwards, as some pigments are not for digesting!

Here have been briefly mentioned just some of the ways of the painter, things that can be done and others that should be avoided. Today, much of the doubt and sorrow has been removed for the artist with regard to his materials; in most cases they have been made as perfectly as the colourman can. Brushes behave as you would expect. Papers and canvases are reliable. So follow some of the hints given, use the various media in the ways suggested, and it should all be there for the doing. There is one way and one way only to progress with your painting and that is to keep at it – to immerse yourself in what you will surely find is one of the most absorbing and satisfying of creative pursuits.

5 Mounting and framing

Having completed your paintings, they deserve as good a presentation as possible. More than this, it is only after mounting and framing that they can really be judged. It can be encouraging to see how, with a little care, a well-chosen mount and a suitable frame, a picture which may have looked somewhat disappointing can be given a lift.

Water colours should always be framed with a mount. There are numerous tinted cards available in different thicknesses. One should be selected that complements the general tint and tone value of the painting and is thick enough to show a well-cut, bevel-edged 'window'. To cut a mount successfully you will need a very sharp craft knife; a scalpel will not do as the blade is just not strong enough and will bend or even snap. There are special mount-cutting devices available with blades set into a specially constructed handle. If you do not want to run to one of these, at least procure a heavy steel rule or a wooden rule with a steel edge. Lay out several thicknesses of newspaper on an old piece of hardboard on the work table. Rule the size of the window lightly on to the mounting card. The two sides and the top should be the same width, and the bottom should be slightly wider. If possible, secure the steel rule along the first cut-line to be made with 'G' clamps and then, with the knife held at an angle of about forty degrees from the vertical, draw it smoothly down the guide-line. Care is needed to start and finish accurately at the corners. Repeat the process with the other three sides.

The painting should be secured to the back of the mount with strips of heavy tissue or thin paper that are called 'guards'. The picture itself should never be stuck directly to the mount. If the paper it is painted on is a little